DESERT ADAGIO

Doug Rhinehart

Appreciation by
Karen Chamberlain

People's Press
Minds Wide Open

Published by People's Press

Post Office Box 70
Woody Creek, Colorado 81656
www.PeoplesPress.org

People's Press Mission

As the world becomes increasingly global, the need grows for community and for the cultivation of community identity through artistic insight. People's Press will search for books and the means to publish and distribute them to this purpose.

Library of Congress Control Number: 2009934154
ISBN: 978-0-9817810-4-4

Photographs by Doug Rhinehart
Book design by Rainy Day Designs

Typeset in Interstate
Produced by Hudson Park Press, New York
Printed by Doosan Printing, Korea

ACKNOWLEDGEMENTS

In the more than forty years that I have been exploring and photographing the desert regions, many, many friends and family have accompanied me on my trips and have encouraged and supported my photography. Any list attempting to recognize those who have helped and believed in my photography and this book can only end up incomplete. Thank you. An additional acknowledgement must go to my photography students whose eagerness for the desert and their fresh ways of seeing inspired me.

Thanks to all – and you know who you are!

A hearty and gracious acknowledgement goes to People's Press for the publication of this book. Thanks to George Stranahan for accepting my idea and for his support of my photography over the years. I am indebted to Mirte Mallory of People's Press for being my guide through the entire process. In addition to her creative and artistic talents, I very much appreciated her boundless enthusiasm. I am so fortunate to have the talent and expertise of Craig Wheeless and the team of Rainy Day Designs for the book design.

Finally, never enough thanks can go to my immediate family, my wife Jean and daughters Janice and Tricia. Your love, support and encouragement over the years are deeply appreciated.

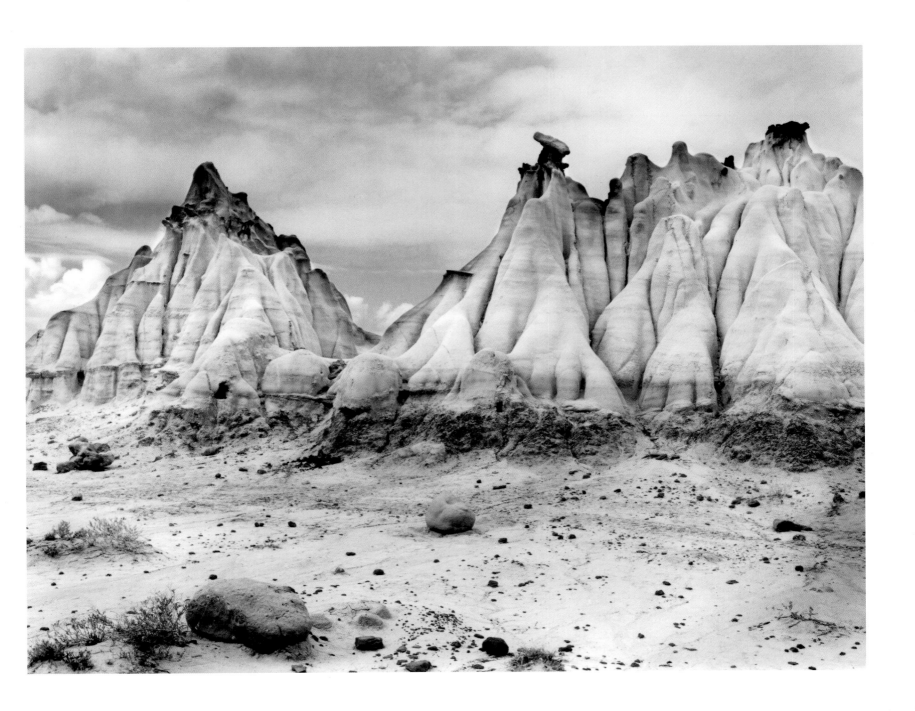

Plate 1: Shale Formation, Colorado Plateau (2000)

**"Doug's photos speak to
the silence of the desert."**

First, there is the magnificent desert itself, which in Doug Rhinehart's photographs includes not only the sere terrains of southeastern Utah, but also the Mojave and Sonoran deserts and Death Valley. Varied as these landscapes are − red-walled canyons, arches, fins, elephant-toed talus creases, velvety bentonite mounds − each is defined by, and awes us with, basic elements of mass and shape, texture and color.

Take away the element of color, as Doug has in these elegantly crafted large-format photographs, and what remains? For me, an increased ability to see and feel two other fundamental desert qualities: light and silence. The simple drama of form, of Earth's naked and weathered skeleto-musculature, is intensified − and above all sensualized − by the mysterious interplay of light and shadow. The brazen, metallic quality of desert light is softened by the shapeliness of the landforms it infuses − and ultimately by the skilled judgment of the photographer.

Accompanying the sensuality of desert forms, a powerful sense of presence is inherent in, say, the towering Wingate walls of a canyon, the mysteriously alive, humanoid shapes of the bentonite mounds Doug so beautifully brings to life, and in such component details as dry, cracked mud, whose fertility is evidenced by the sprig of sage sprouting from its cracks. We are reminded that the macrocosm of rock, hills and sky, sparse as it may seem, nourishes microcosms of living beings. And that even the black rocks that appear to be traveling between folds of bentonite actually are on an erosional journey.

If light creates the desert's visual and tactile revelations, its auditory element is silence. But is the desert truly silent? Or merely quieter than most places? In the desert one hears the obvious sounds of wind, birds, insects and airplanes. But beneath those sounds, in remoter places, can be heard the murmur of silence − a kind of slow hum, a skeletal song.

The desert silence is not empty, but rings and vibrates, sings and wheezes with the speech of particles and waves and streaming ions, the music of galaxy and cosmos, the whispers of light and darkness comingling. And whether this is indeed an audible music of the atmospheres, or whether it is due to the keening of our own blood through ears and brain, the desert's silence is as alive as its landscapes.

How does a photographer capture silence? Is it inherent in the visual imagery arrested by his camera? Or is it a quality created by careful work with the camera and in the darkroom? In Doug's photographs, I believe it is both. In the desire to have his visualization evoke emotional as well as aesthetic response, the photographer manipulates the found image into a composition – in the musical as well as the visual sense.

While some photographers might jazz up their compositions into high contrast, chiaroscuro allegros, or ultra-soft gray lullabies, Doug's images strike me as having the same slow rhythms as the desert he photographs. This is no small feat, but is generated by his great care to have the printed image honor both its subject and his feelings for that subject.

In conclusion, allow me to draw attention to my favorite of these many photographs I appreciate, the image titled "Tree in Side Canyon" (Plate 13). In it are contained all the qualities I love about Doug's photographs: the elegance and dimensionality of its composition, the living presence of its content, and the exquisite slow dance of the tree with sunlight. Truly a desert adagio.

Karen Chamberlain

A poet since childhood, Karen Chamberlain co-established the Aspen Writers' Foundation and worked as senior writer and associate producer for the PBS-TV nature series, Wild America. Her poetry, widely published, has won several national awards. A memoir, Desert of the Heart: Sojourn in a Community of Solitudes, released in 2006 by Ghost Road Press, was a finalist for the Colorado Book Award and continues to receive high praise from readers and the media.

The ambiance of darkrooms is akin to being in a dimly lit cave. They are, for the most part, utilitarian and they smell bad and are suffused in a rather sickly amber glow. In an attempt to overcome what could be stifling and depressing surroundings, I turn to music. Music is a vital ingredient for my darkroom sessions, as much a part of my work environment as the chemicals or the paper. The darkroom allows me the greatest degree of personal expression in the photographic process and it is important that I approach a printing session with a creative frame of mind. As the printing session continues, I also need to maintain a pace and a rhythm that will support and nurture the work. The music that I play is not just background but an accompaniment to the creative process. In working with the desert images, I find that the slower movements in classical music, in particular the adagios, seem to match and even nurture my inner rhythm and emotions as I work with the negatives. The adagios are expressive of how I want my images to speak to the viewer. I find as I work with the prints, the adagios bring out feelings within me that are very similar, if not identical, to the feelings I experience while in the desert.

The desert, like any environment, has its own rhythm and pulse if you take the time to consider it. More often than not, I interpret the rhythm of the desert to be one of calm and tranquility. The movement is slow, gentle and meditative. For me, there is a pervasive sense of awe. So many times when I am photographing, I feel the pulse of the desert and consciously try to tap into it in order to guide me in the selection, composition and exposure of a scene. After I have finished composing the image, and have come out from under the dark cloth to stand next to my camera and release the shutter, I carefully study once more the subject I will photograph. The feeling of awe rises from deep within.

I want my prints to speak softly and with simplicity as an equivalent expression of my feelings and emotions when I took the photo. Ansel Adams liked to compare the negative to a musical score and the print as the performance. In order for my prints to be successful in their communication, I too, must interpret the negative and listen to the prints as I work with them, eliciting and coaxing from them as much as I am able to draw. Printing is not a robotic, cookie-stamping procedure but takes the human brain, the human eye, the human hand, and employs human interpretation. I will draw out subtle detail in a shadow, or more luminosity in a highlight area. I may carefully darken selected areas within the print in order to guide the viewer to the center of interest. I may decide to add more contrast in order to give the print more drama, more volume. I may lessen the contrast to lend a softer presence. The interpretations are wide-ranging and up to me to bring them to the print. Therefore, the ambiance of the darkroom is vital.

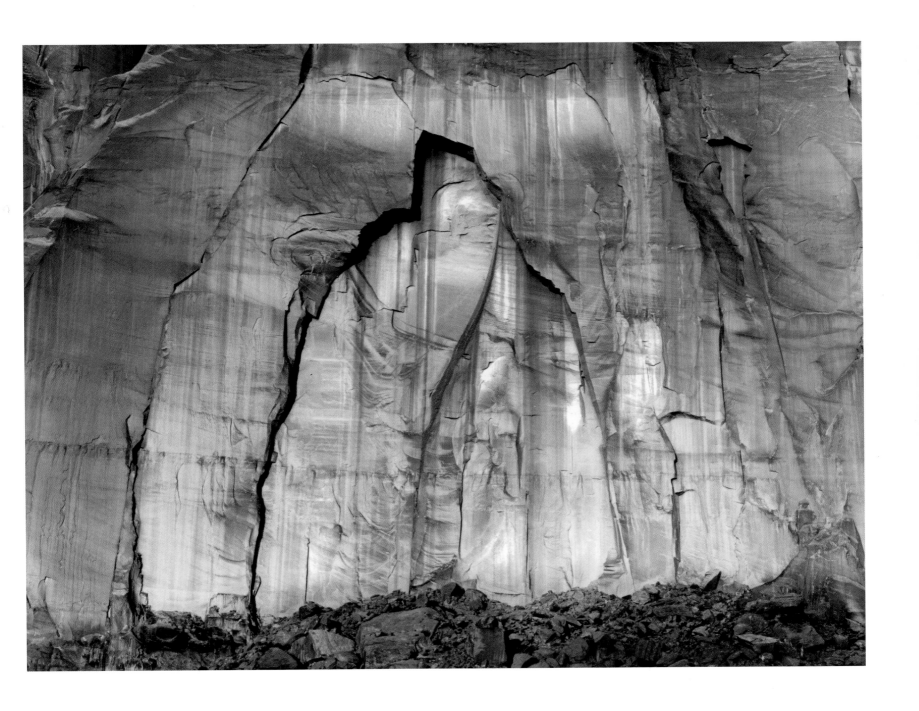

Plate 2: Desert Wall With Figure, Monument Valley, Arizona (2008)

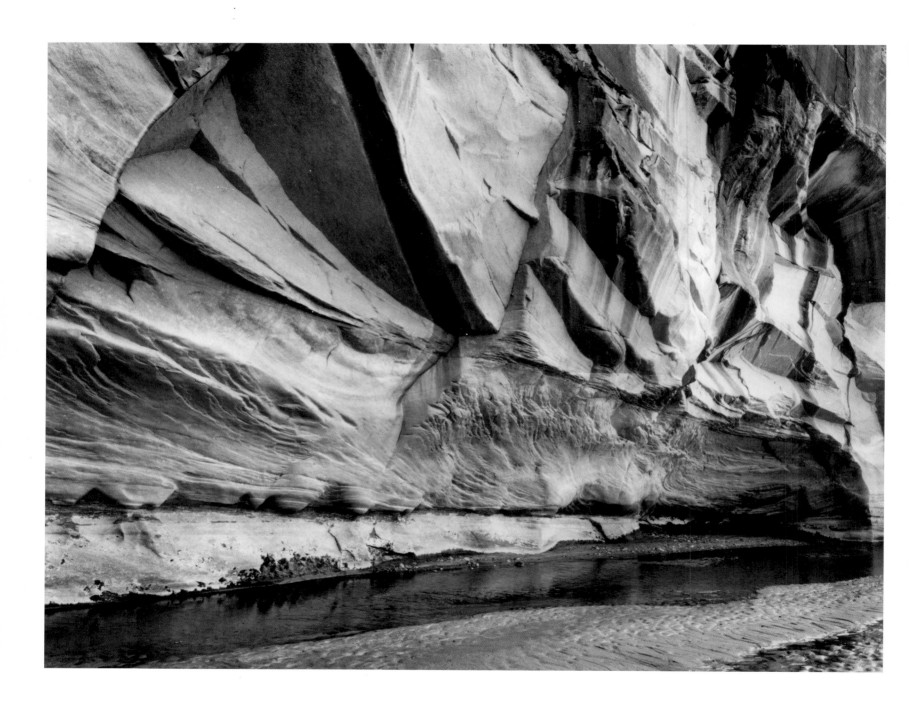

Plate 3: Desert Wall With Wedges, Colorado Plateau (1996)

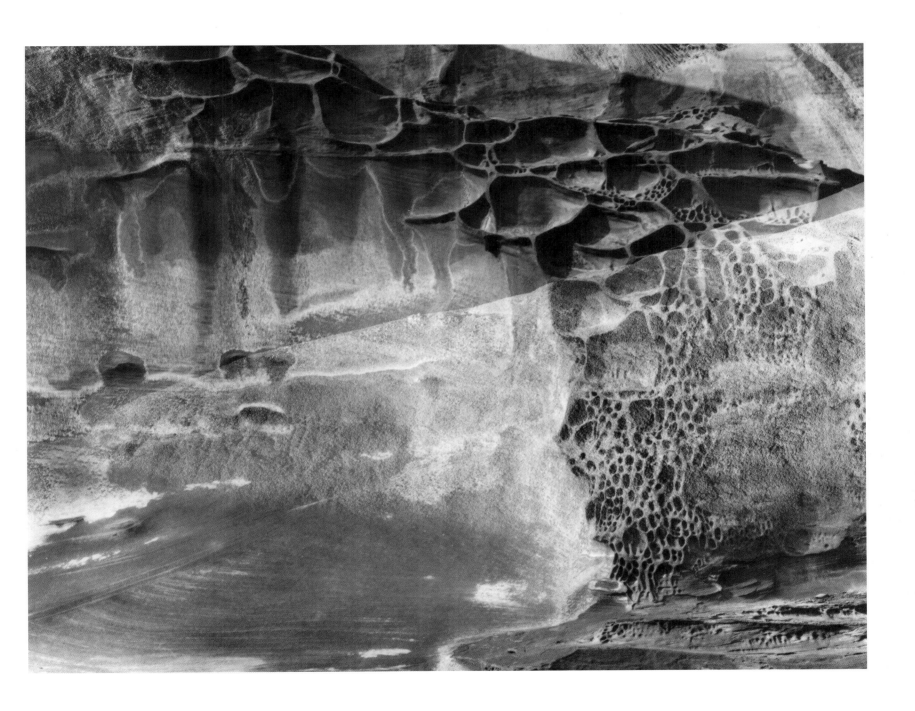

Plate 4: Abstraction, Sandstone Wall #2, Colorado Plateau (1996)

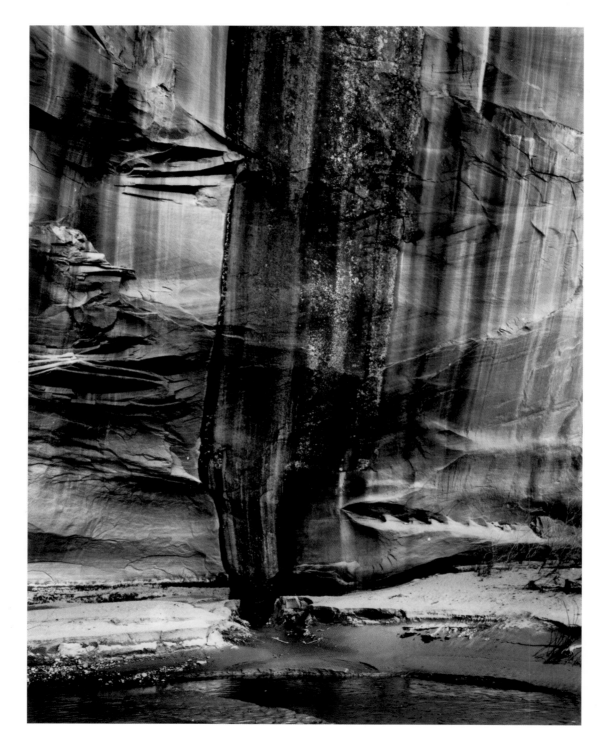

Plate 5: Black Waterfall, Colorado Plateau (1997)

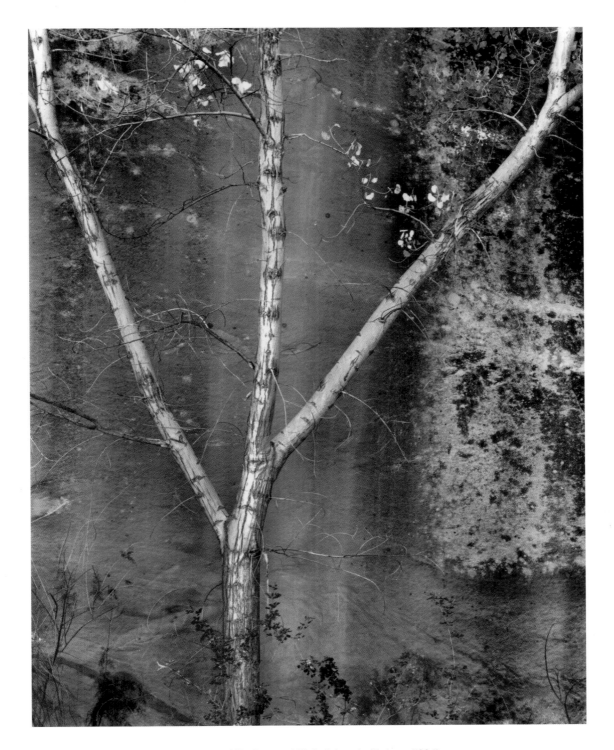

Plate 6: White Tree and Wall, Colorado Plateau (1996)

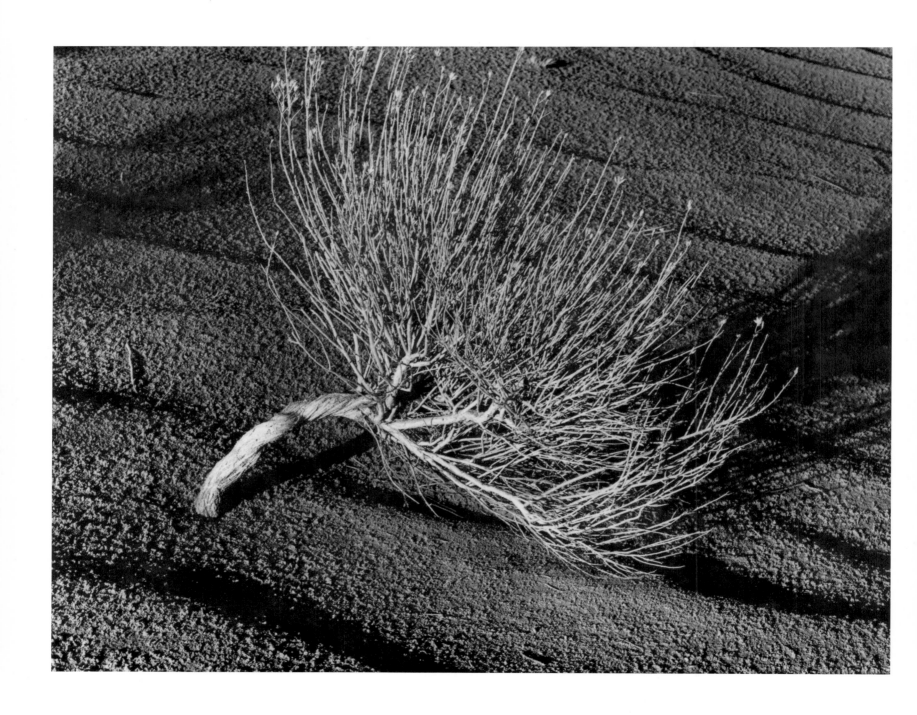

Plate 7: Sagebrush and Sand, Monument Valley, Arizona (2008)

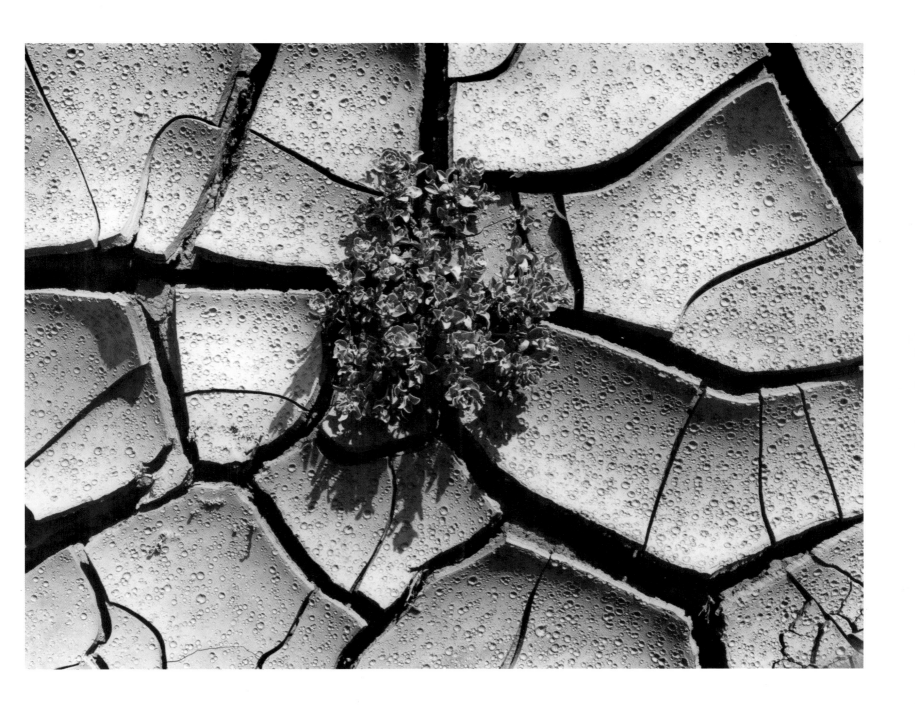

Plate 8: Cracked Mud and Plant, Colorado Plateau, (1999)

Contrary to the opinion expressed by a friend of mine who commented, "I just thought deserts were something you had to drive across," there are many reasons to go to the desert. My friend hadn't seen the spectacular bare-boned landscape, the wash of wildflowers in the spring, or the almost trite sunrises and sunsets. He hadn't floated on desert rivers, hiked in canyons, or simply gazed up at tapestry walls. He hadn't heard the song of a canyon wren, or looked closely at the detail in an ancient potshard or panel of rock art. Even then, seeing and doing those things, some of which could even be accomplished on a tour bus, doesn't ensure that the visitor will really know what the desert means. I too, go to the desert for all of those reasons, but there is also something more, something deeper that draws me back.

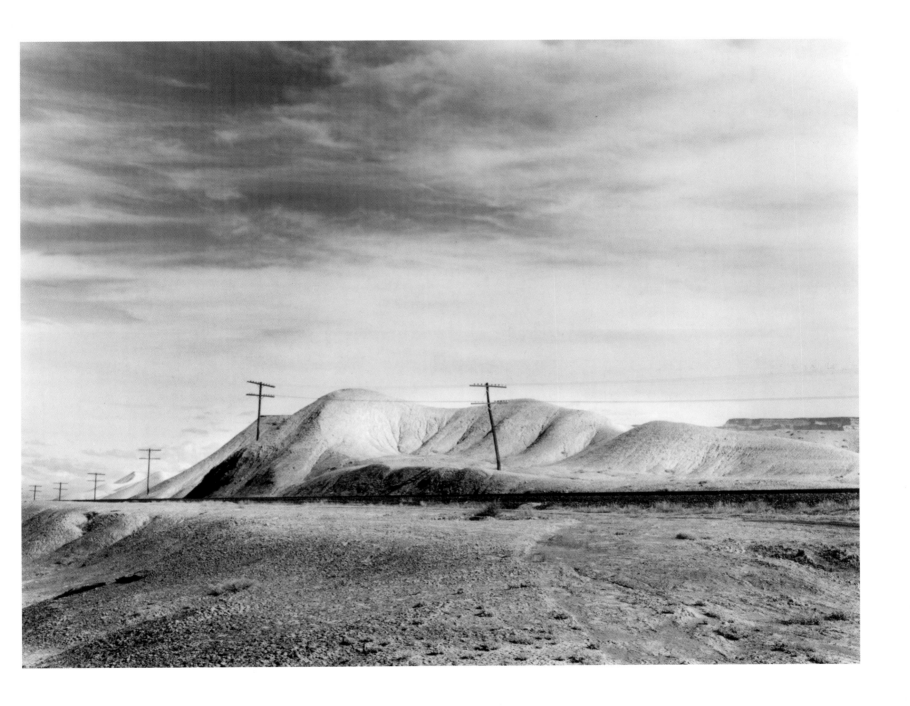

Plate 9: Railroad Track and Poles, Colorado Plateau (1996)

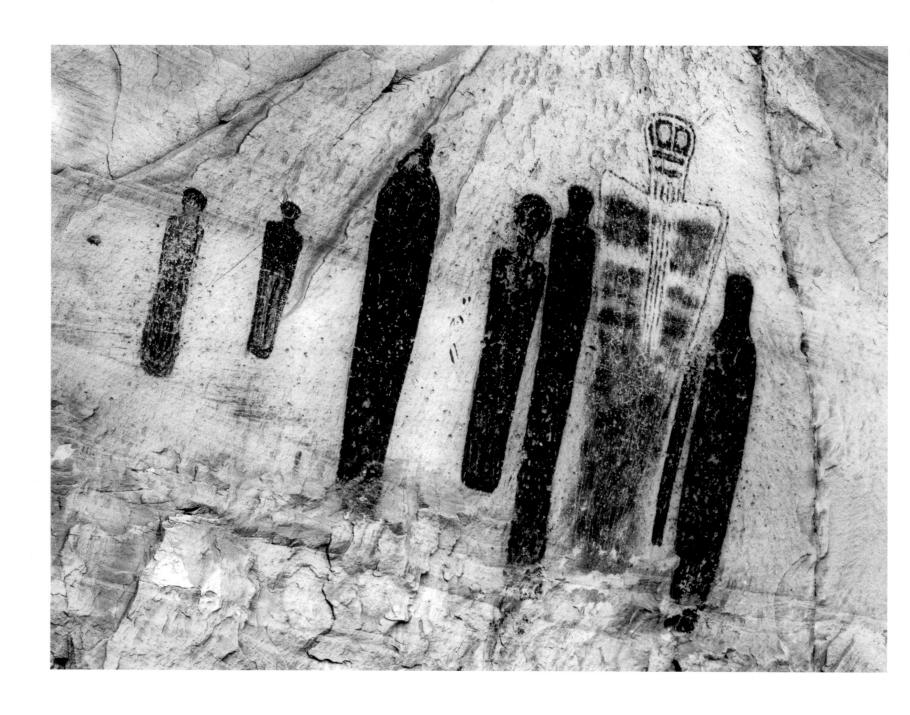

Plate 10: Rock Art Panel, Colorado Plateau (1998)

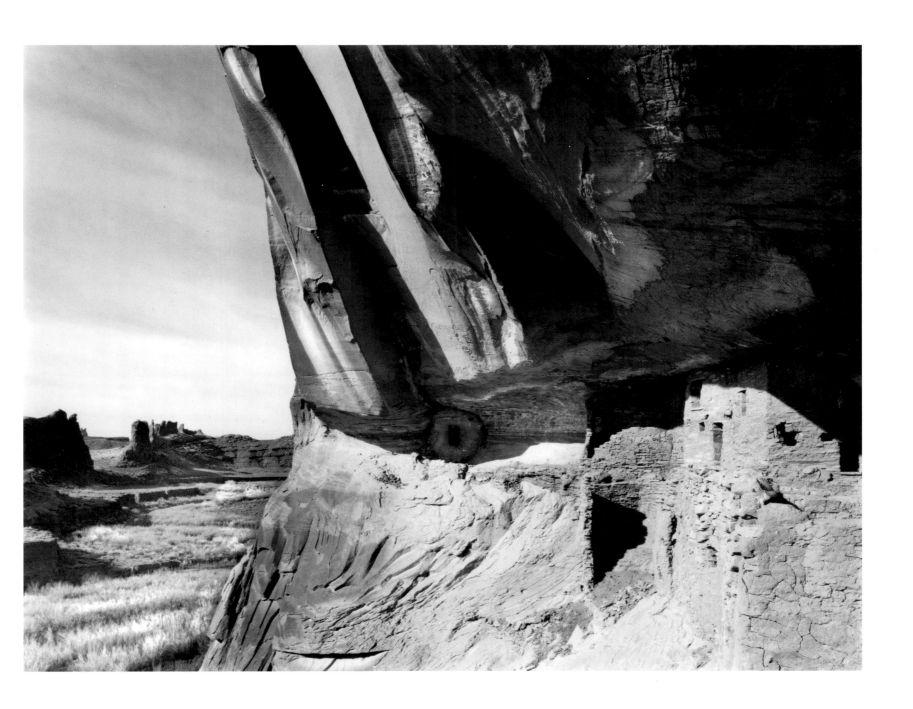

Plate 11: Cliff Dwelling, Colorado Plateau (1997)

My first trip to the desert was forty years ago. I was a new teacher in Aspen High School, and I was asked to help chaperone the graduating seniors on their traditional sneak trip. They were going to a place I had never heard of, Arches National Park. Since it would be new to me and because I would get out of a few days of teaching classes, I agreed.

I had just started to get involved in black and white photography and took my camera to the desert for the first time. I took snapshots of the students, but also picked up my camera early in the mornings and late in the afternoons to wander away from the camp to be by myself and visually explore that compelling environment. Just a few hundred yards from the camp I discovered that most alluring attribute of the desert – the silence.

The silence of the desert matches the landscape: It is stark and barren. It is so utterly silent that it is startling when first encountered. You find yourself straining to hear something. You may catch the lazy buzz of a lone fly nearby, or the soft rustle of some cottonwood leaves. Other times, you may be listening to nothing but the sound of your blood coursing through your eardrums.

I find that when I am photographing, I respect the quiet; I become reverential and work quietly. I sometimes feel a little sacrilegious even letting my shutter click. Frequently, when I am working in other environments, I mumble out loud as I fuss around determining the composition and the exposure: "Oh, let's see, I think I better use a yellow filter and go at f-22..." I restrain myself in the desert.

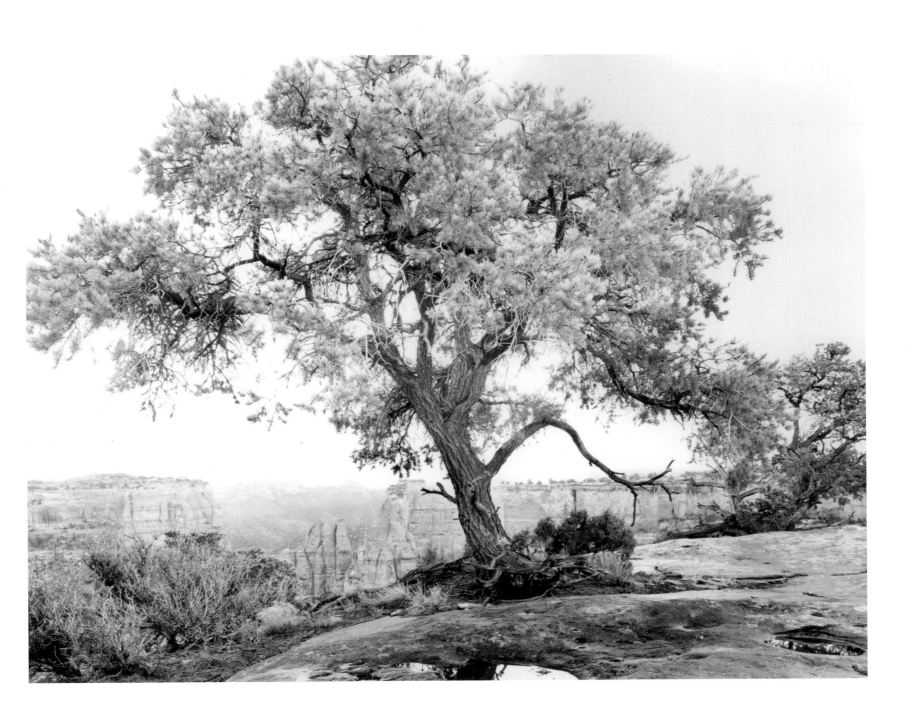

Plate 12: Snowstorm, Colorado National Monument, Colorado (1999)

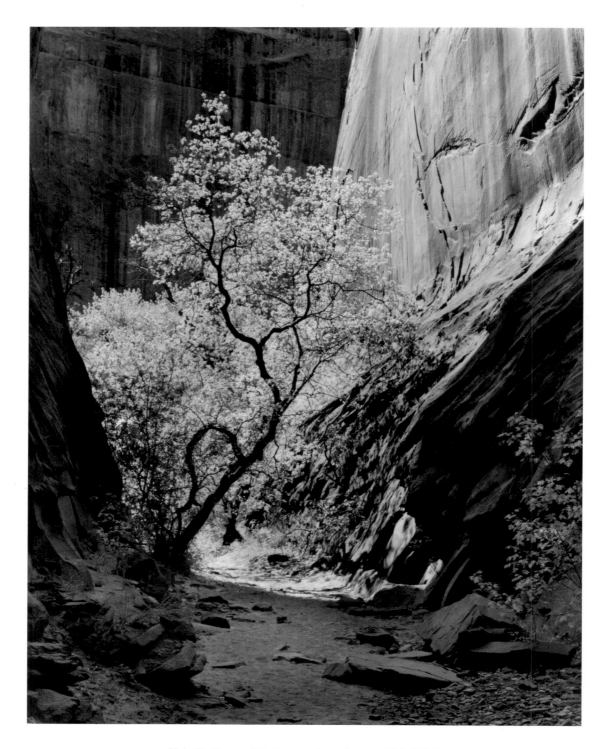

Plate 13: Tree in Side Canyon, Long Canyon, Utah (1996)

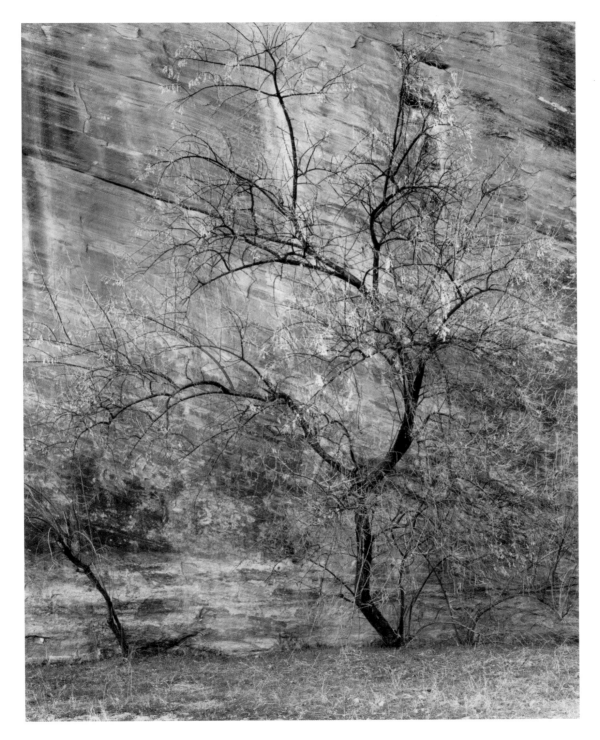

Plate 14: Tree and Wall, Canyon de Chelly National Monument, Arizona (1999)

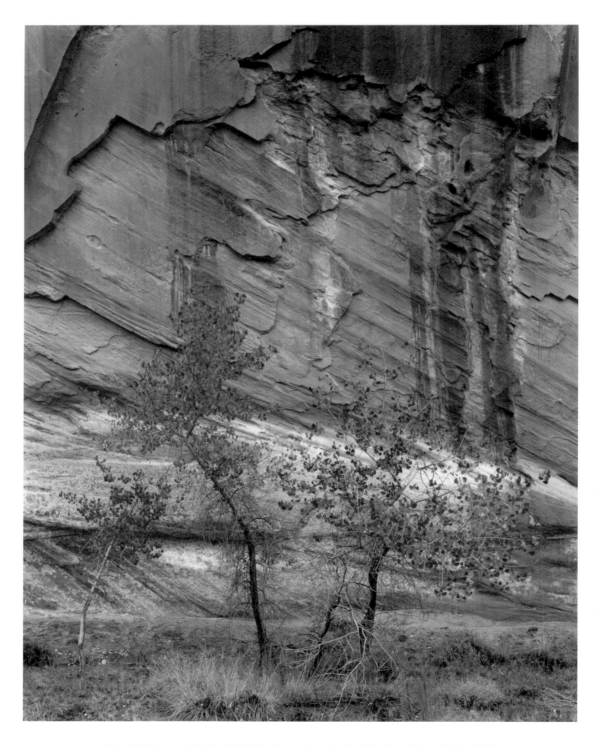

Plate 15: Tree and Wall with White Stripe, Capitol Reef National Park, Utah (1993)

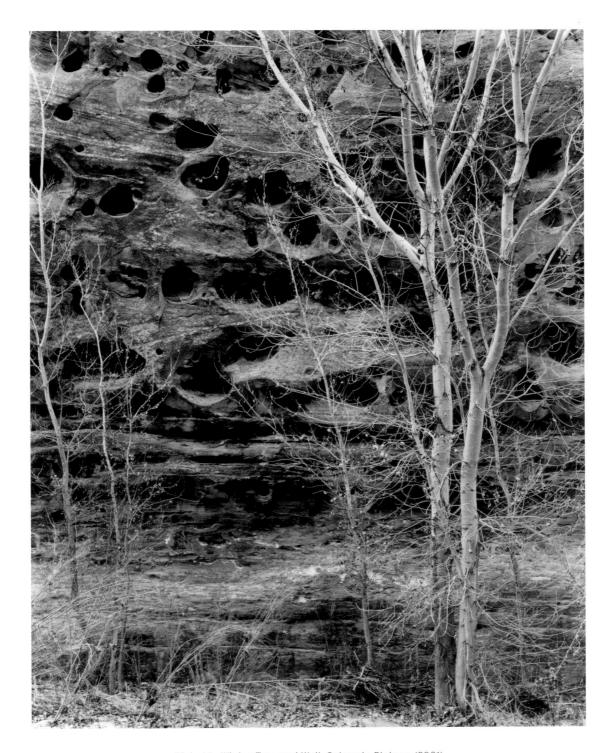

Plate 16: Winter Tree and Wall, Colorado Plateau (2001)

What I have experienced in the desert, I have not experienced in any other environment. While the other appealing aspects of the desert begin with my senses, this feeling rises from deep within and tells me that I am back. Back to my soul home. Very soon upon returning to the desert, I feel myself adjusting to desert mode. I take many deep breaths and feel tension leave my body. My pace and rhythm slow down and I seem to consciously match my pulse to the rhythm of the desert. Edward Abbey wrote about our need to connect with something intimate in the wilderness. I feel and act as though I am in the presence of something sublime. It is during those sublime moments that the objective with my photography is clear; I want the resulting print to express to the viewer what is in my soul at the moment of releasing the shutter. I am not interested in depicting the subject, to simply show what it is. Rather, I want the photograph to go beyond subject matter and to express what the desert means to me, my relationship with the desert. My relationship is one of having a sense of place and being connected. There is something within me that yearns toward the visible forms offered up by the desert and it is a feeling and a recognition of being a part of a coherent whole. The rocks, the plants, the trees, the clouds are all interrelated parts of the whole. Robert Adams, the writer/photographer, defined art as "a discovery of harmony."

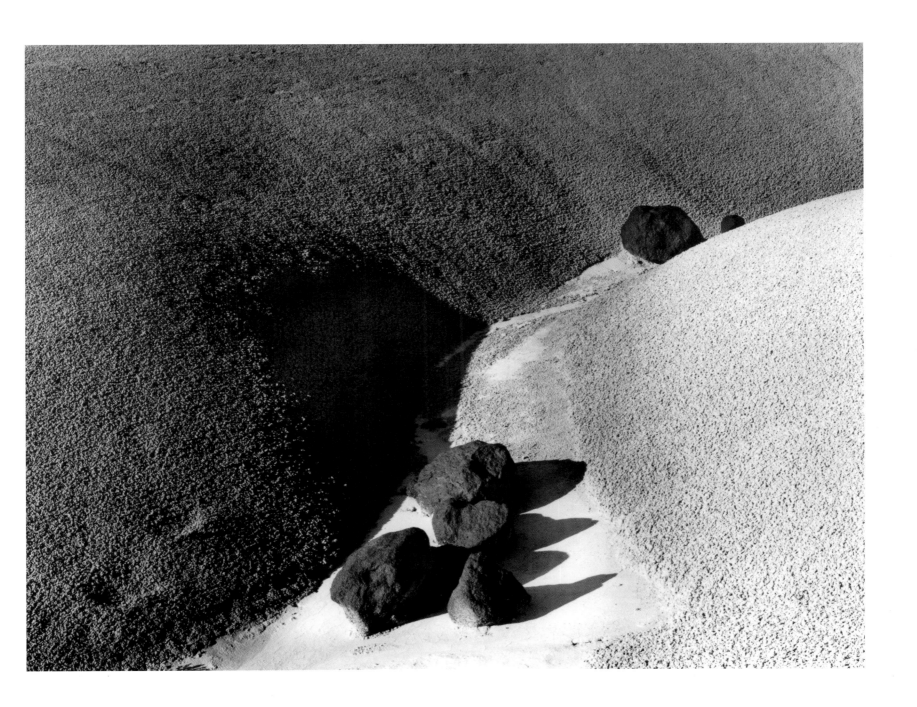

Plate 17: Bentonite Mounds #4, Colorado Plateau (1993)

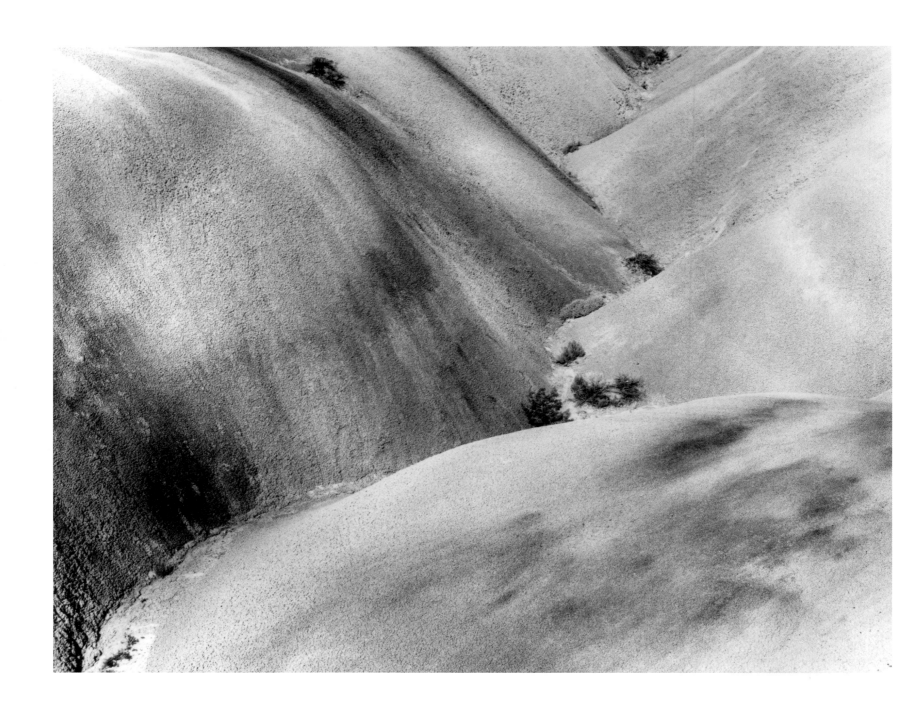

Plate 18: Bentonite Mounds #7, Capitol Reef National Park, Utah (2005)

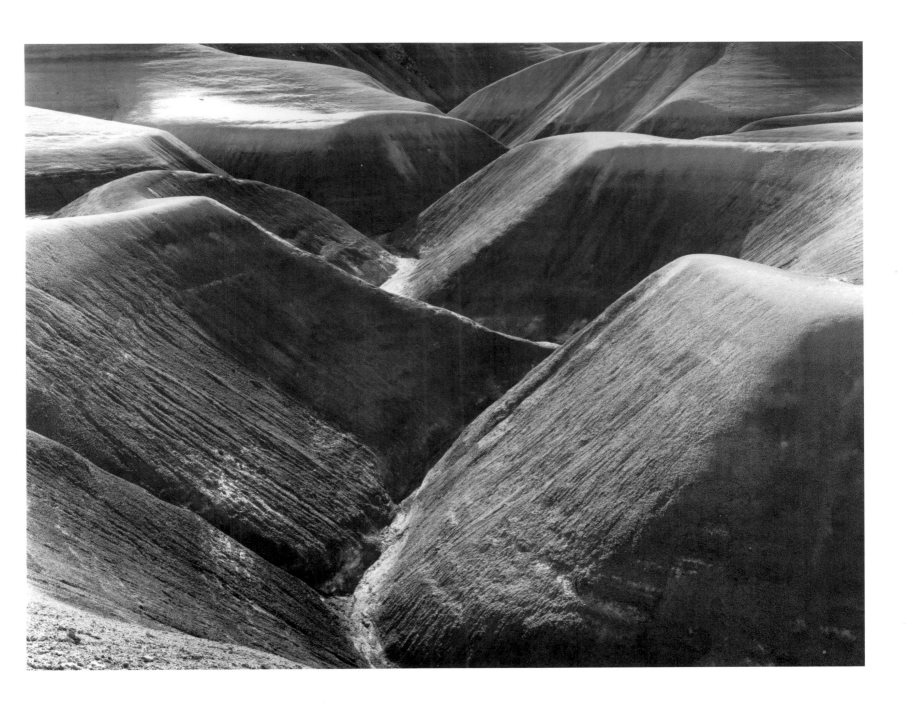

Plate 19: Bentonite Mounds #1, Colorado Plateau (1995)

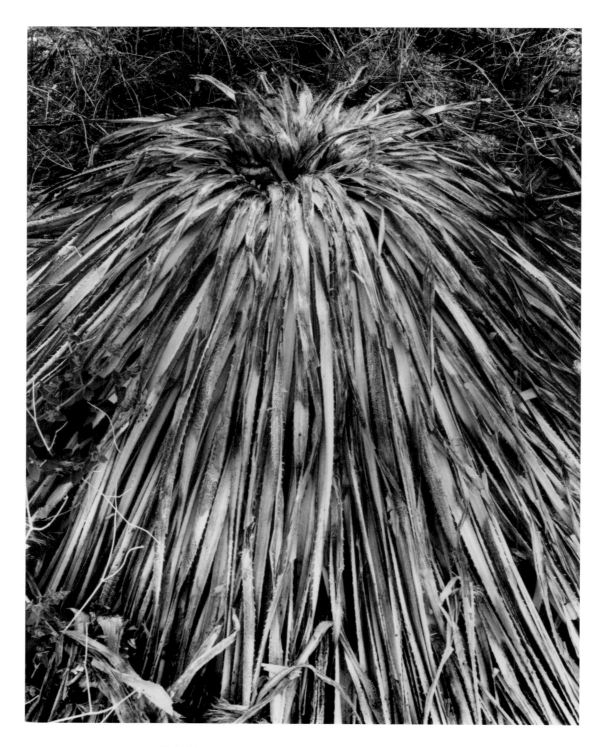

Plate 20: Dried Yucca, Catalina State Park, Arizona (2005)

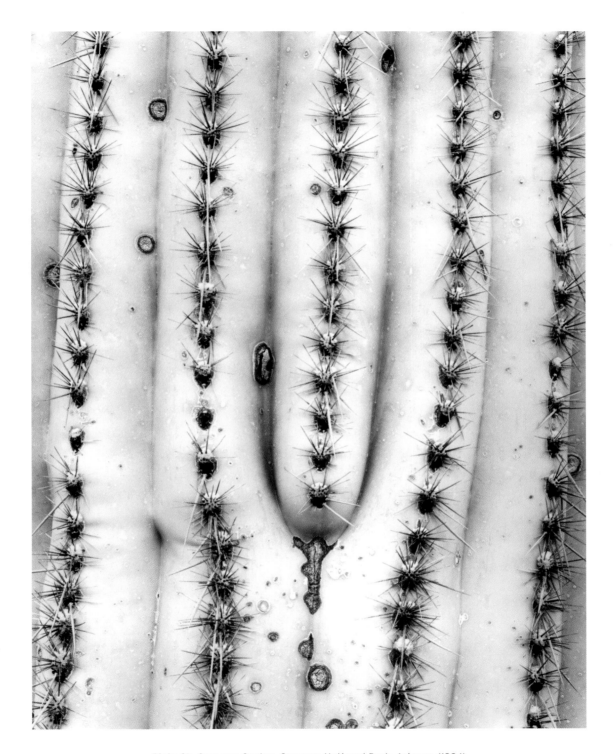

Plate 21: Saguaro Cactus, Saguaro National Park, Arizona (1994)

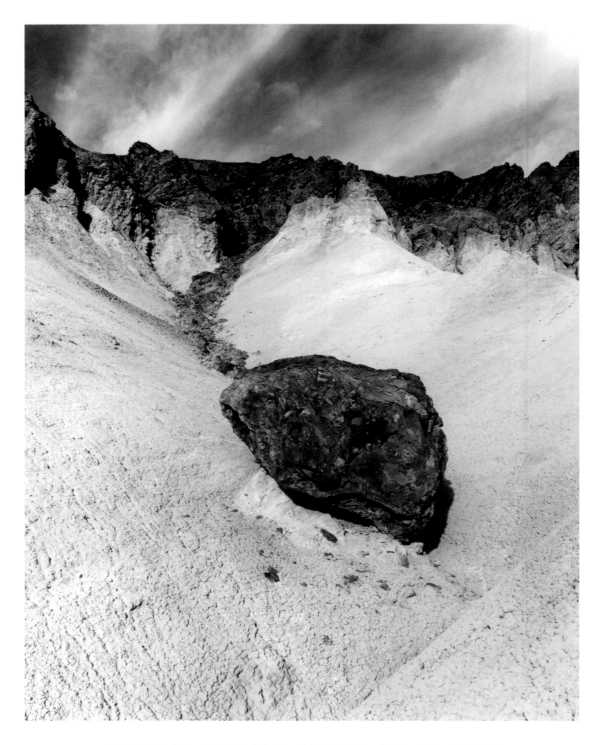

Plate 22: Black Rock in White Hills, Death Valley National Park, California (2006)

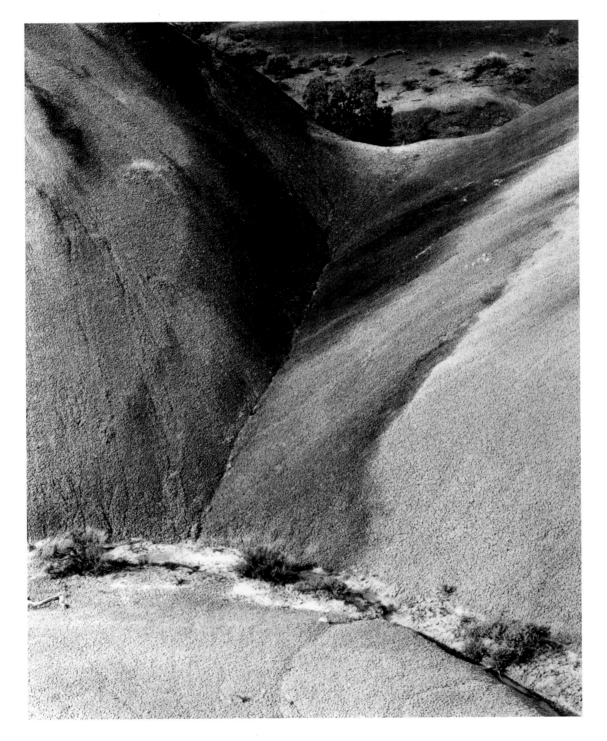

Plate 23: Bentonite Mounds # 6, Capitol Reef National Park, Utah (2005)

By no means are all my thoughts and feelings about the desert sublime. I fear for the desert. I will never forget the angry comments made by a Moab citizen whom a friend of mine encountered at the Needles Overlook in Canyonlands. As my friend gazed in wonderment at the awesome panorama before him, he commented to this man something about the incredible beauty of the scene at which they were both looking. The man actually seemed to be glowering as he shot back, "It's a goddamn waste is what it is! We could have had a nuclear dumpsite out there but the sumbitches took it away from us! Hell, I have a right to make a livin', don't I?"

Like all wilderness areas in this country, there are more and more demands put upon the desert, some appropriate and some totally inappropriate. We are a capitalistic society, and as such, what drives us and colors our values is money: If it doesn't make money in some fashion, then it is worthless. As a direct consequence, we keep losing more and more areas of wilderness to human development and enterprise. In our shortsighted and all-consuming determination to "make a livin'," we don't grasp the concept that once a wilderness area is lost to the ravages of man, it is gone forever – extinct.

In the forty years I have been visiting the desert, I have seen drastic changes take place. Remote campsites that I have used in the past where I was assured of total privacy are now overrun with a dozen people, dogs, and all manner of vehicles. Where once there had been a single campsite with one fire pit, now there are several campsites with numerous trash-filled fire pits. The ground cover has been denuded. All pieces of wood, whether a picturesque, gnarled juniper or dead branch on a living tree, have long since disappeared along with most of the inherent beauty of the campsite.

The stillness that is such a cherished and unique attribute of the desert is harder and harder to find. With more and more people exploring the desert regions, it is difficult to escape the noise and clamor that seems to accompany human beings. One moment you can be hiking and reveling in the peacefulness of a small side canyon; the next, assaulted by the raucous blast of approaching dirt bikers. Long after they pass, the sound reverberates down the canyon until eventually the silence returns. But it is not the same. Something has been destroyed.

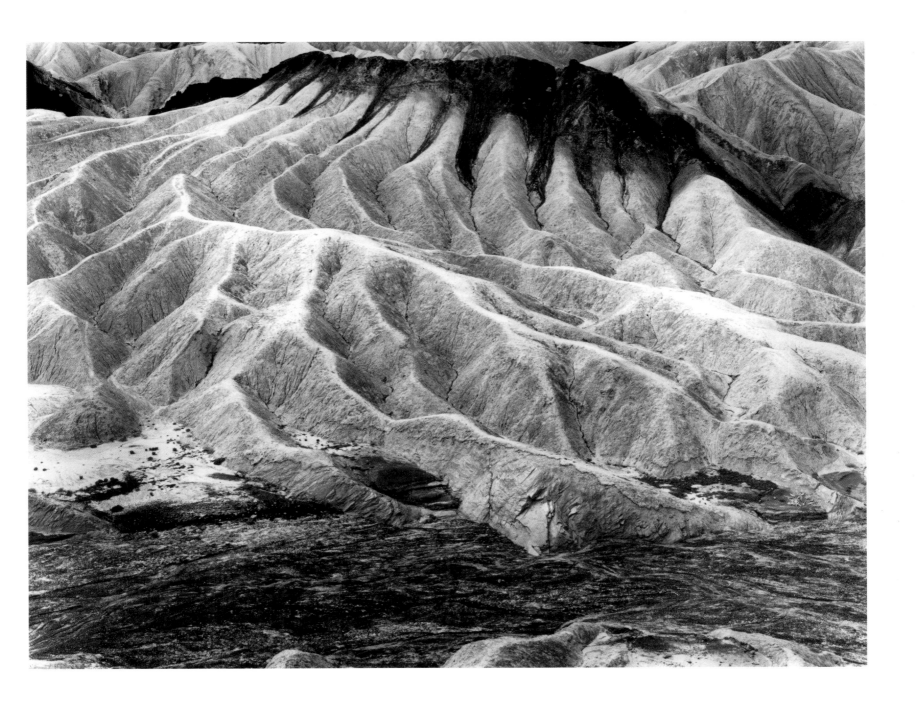

Plate 24: Zabriskie Point, Death Valley National Park, California (2006)

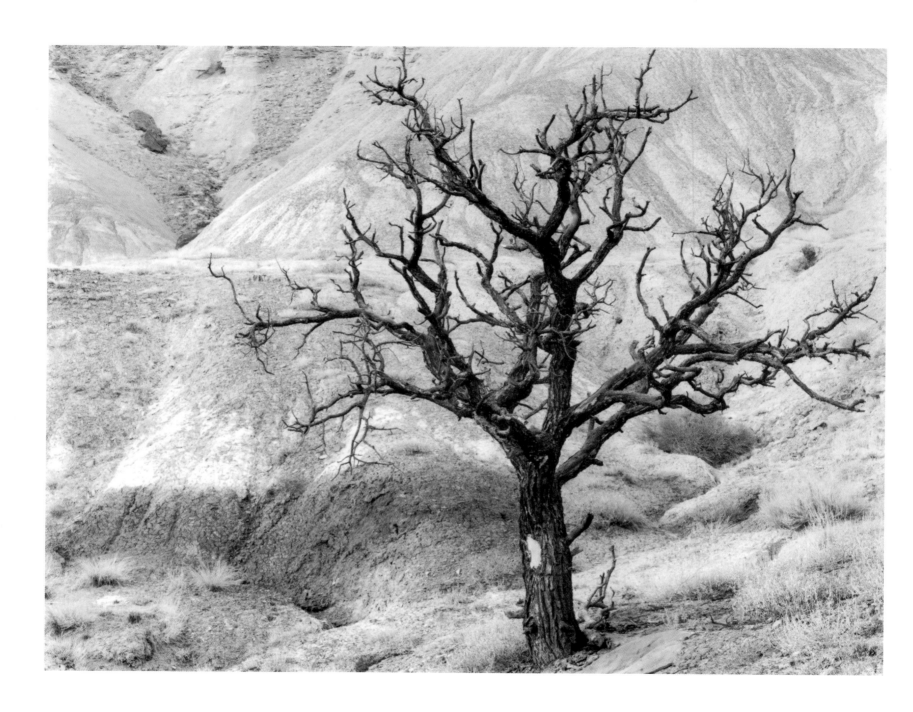

Plate 25: Dead Piñon, Capitol Reef National Park, Utah (1994)

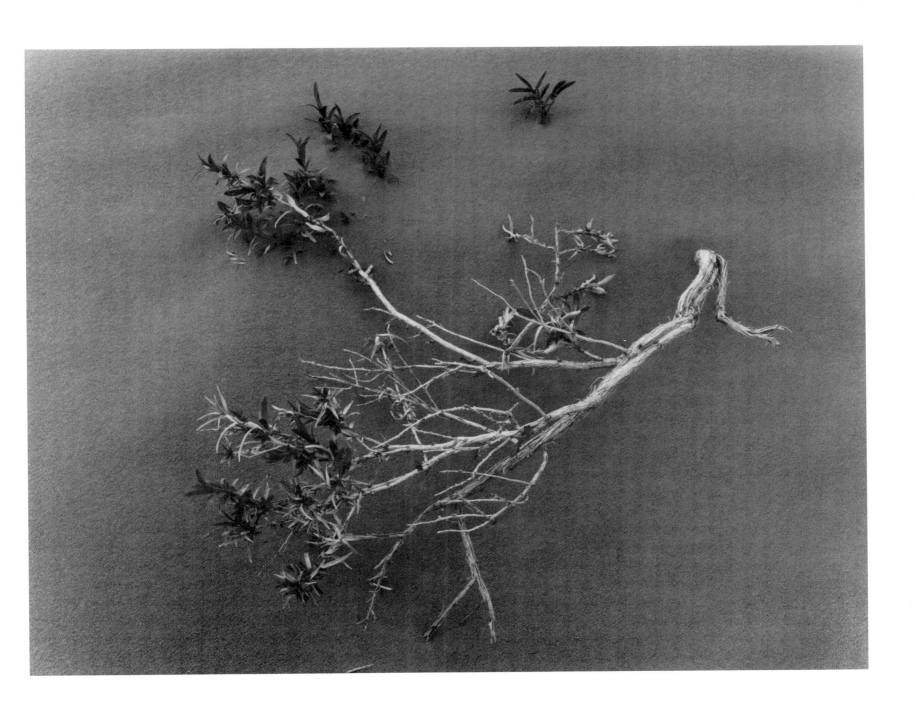

Plate 26: Plants in Sand Dune, Colorado Plateau (1993)

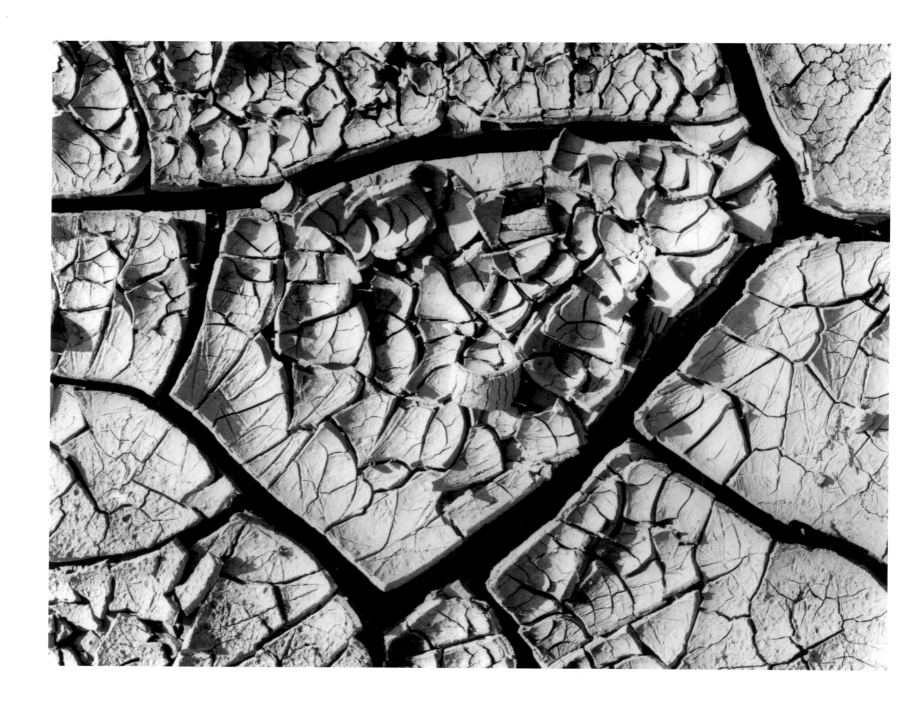

Plate 27: Cracked Mud, Colorado Plateau (1997)

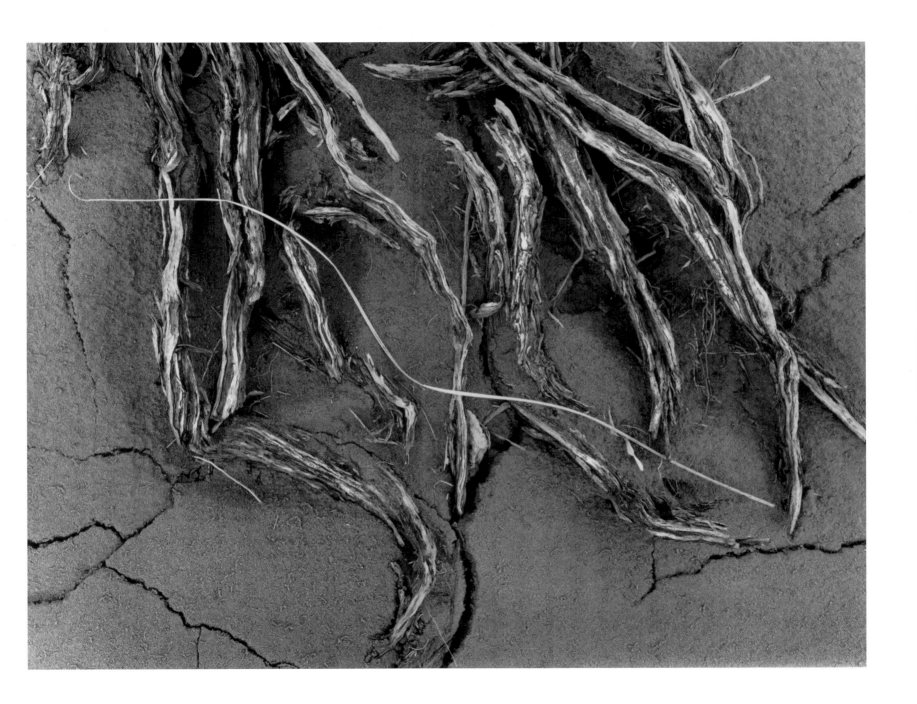

Plate 28: Roots in Sand Dune, Colorado Plateau (1995)

I have seen the sleepy, mostly forgotten mining town of Moab transformed into a seething tourist Mecca, its wide main street crawling with RVs of every size, four-wheel-drive Jeeps and pickups, sport utility vehicles with attached mountain bikes, rafts and kayaks. Moab used to cater to the uranium prospectors – now it caters to the swarming tourists from all over the world. The main street is one long strip of cookie cutter convenience stores and motels, along with schlocky curio and T-shirt stores. And recently it was topped off with an ugly bit of irony for a town smack in the heart of the desert – a water slide. Yes, "Desertland" has come to the desert.

I have also realized recently that many of the people who visit the desert are not seeking to experience its singular beauty. Rather, they are seeking to use the desert. The mountain bikers, dirt bikers, off-road users, climbers, cross-country runners are all using the desert to satisfy some craving they have. The desert is of secondary importance. It is one vast sandbox to which they bring their grown-up toys.

We, who go to the desert for whatever purposes, are all guilty of the destructive human intrusion into such a fragile environment – be it the RV family from Kansas, the yuppie mountain bikers from Boulder or Aspen, the backpackers, the dirt bikers, and, yes, the photographers. Such a thought gave me considerable soul-searching when considering doing a book of my photos of the desert. Am I helping to destroy that which brings me so much joy and solace? Am I exploiting the desert for my own ends?

As far as exploitation is concerned, the answer is yes and no. My intention was not to use the desert to make money. I knew at the start that little or no money would be made on a book such as this. Money was not the object. Yes, I am using the desert as a means to get my photography out there. An artist cannot work in a vacuum. We must have people see our work and respond to it. The desert has served my purpose in that regard, but I am no more exploiting the desert than a portrait artist who uses other people, or a still-life artist who uses fruits or vegetables.

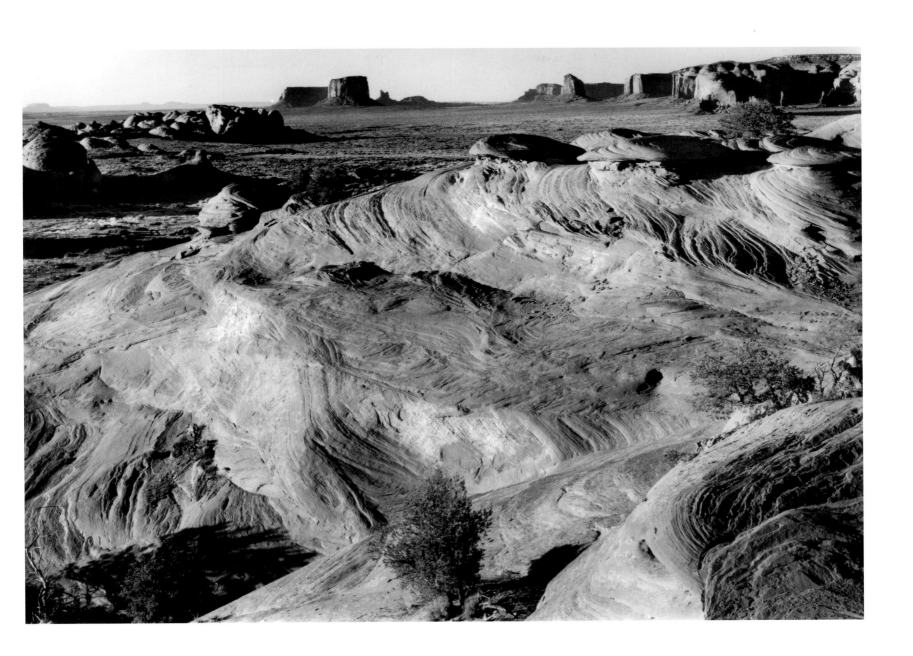

Plate 29: The Pancake Hills, Mystery Valley, Arizona (2008)

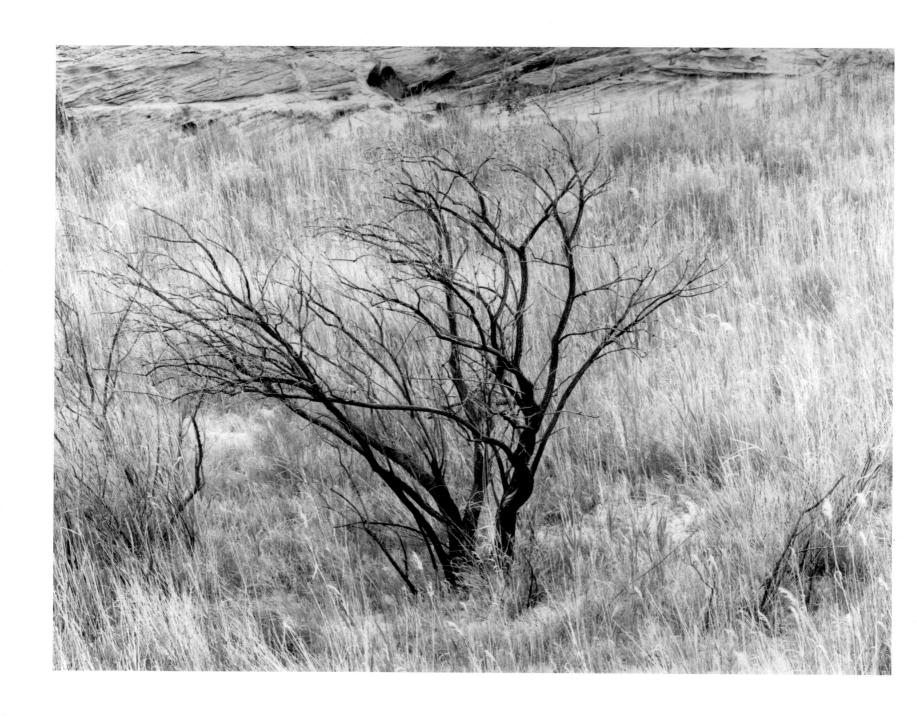

Plate 30: Burned Tree in Grasses, Colorado Plateau (1995)

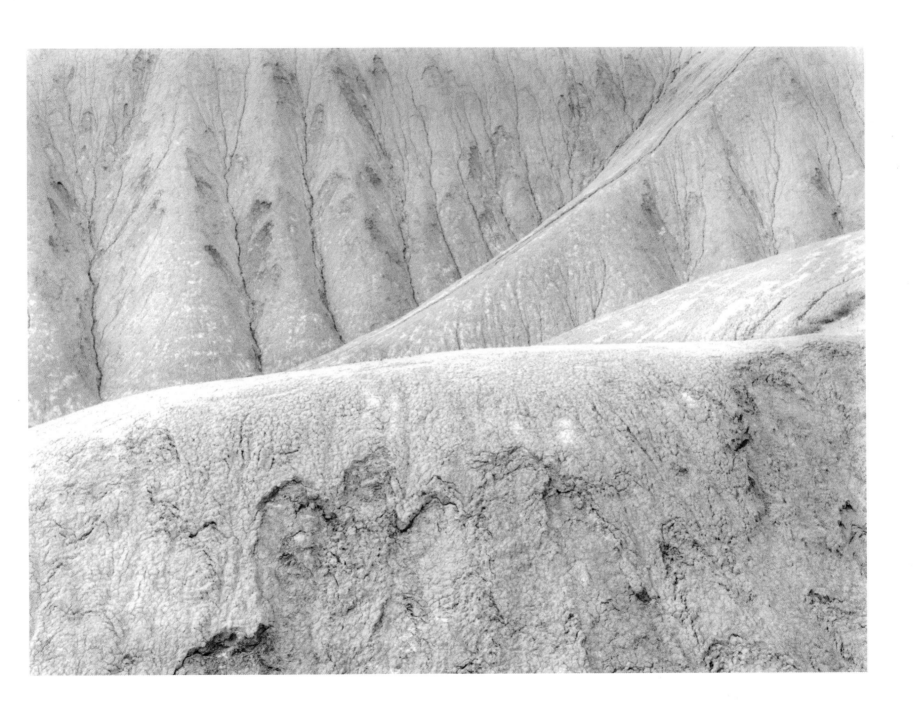

Plate 31: Book Cliffs, Colorado Plateau (1993)

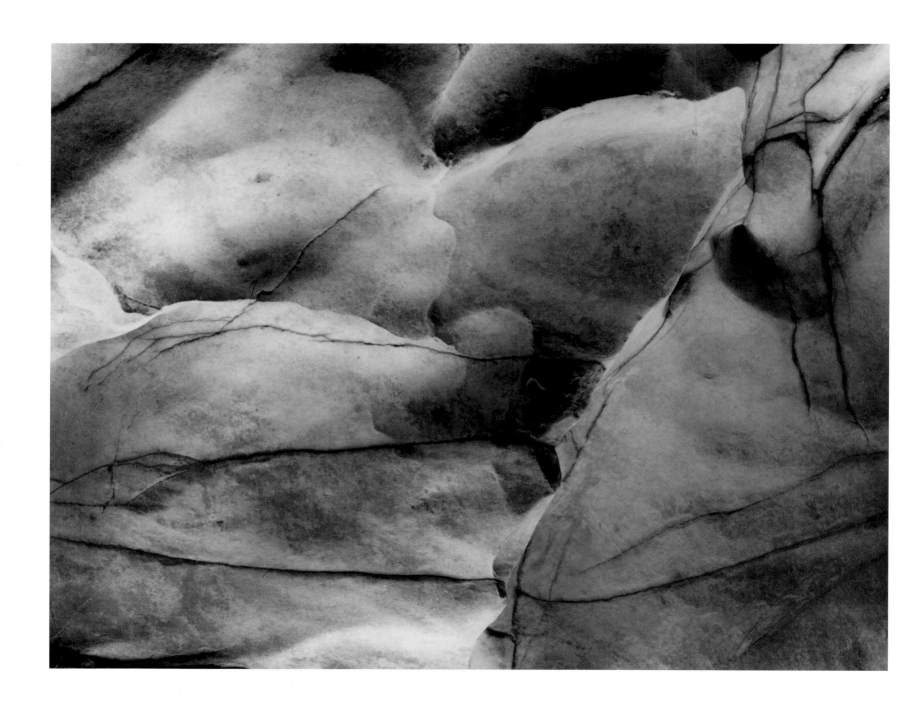

Plate 32: Black Lines in White Rocks, Colorado Plateau (2001)

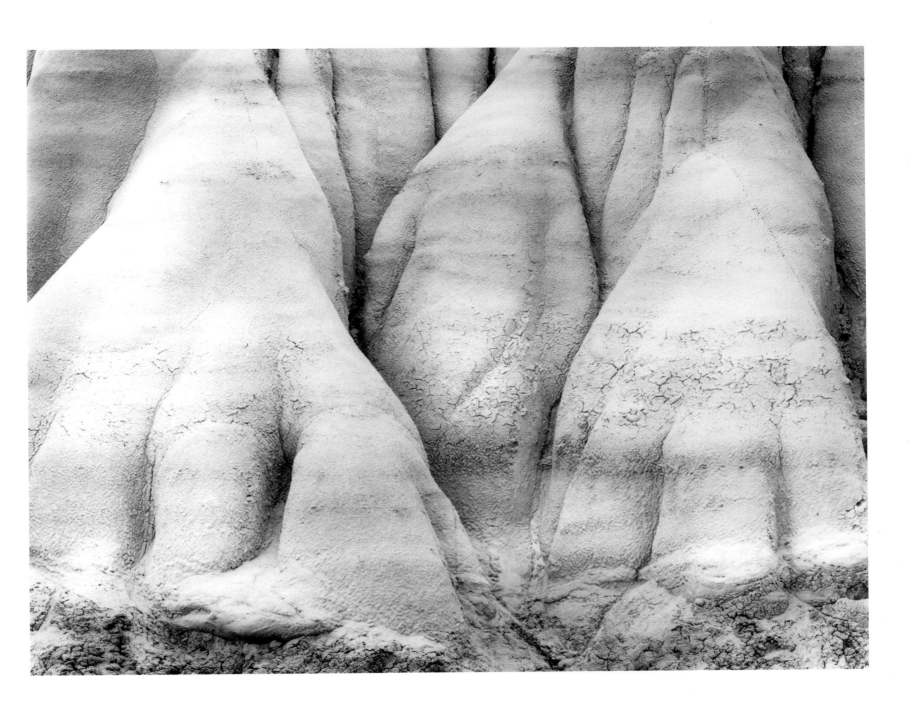

Plate 33: "Feet," Colorado Plateau (2000)

Am I helping to destroy the desert? I, of course, hope that I am not. I had to ask myself whether more people would go to the desert because of my book. I doubt it. People are going to go to the desert anyway, whether I have done a book on it or not. And people new to the area are going to be looking for literature that will guide them and give them facts. It is my hope that my book will give people a better appreciation of the desert and perhaps gain an insight into what the desert means to me. Hopefully, some will join in to help preserve the desert. The desert is not mine, but I will guard and protect it from those I think intend to do harm to it. The desert is not mine, but I will treat it as such and will treat it with the love and care I give to my home. The desert is, after all, my soul home.

Doug Rhinehart

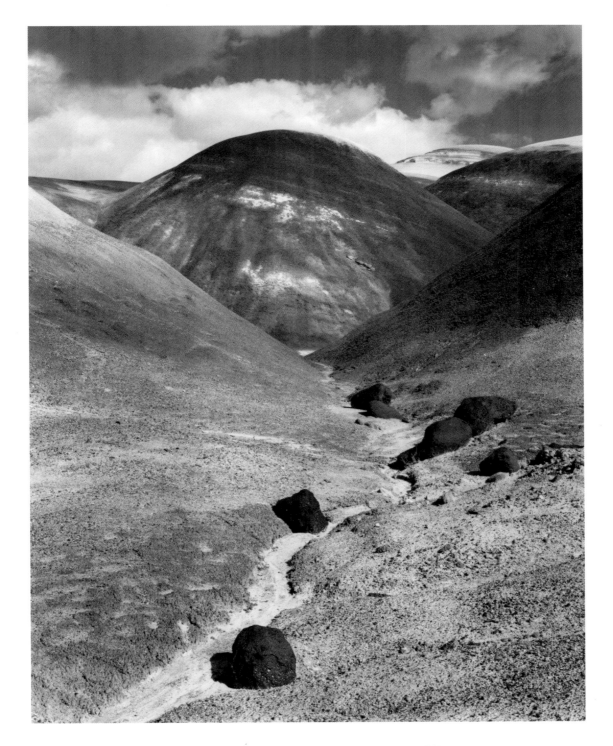

Plate 34: Bentonite Mounds #5, Colorado Plateau (1997)

Photographers differ widely on what technical aspects they will reveal about their photographs. On the one hand, you have those who keep very detailed notes who tell you the format, camera brand, lens brand, focal length, f-stop, shutter speed, and filter used to take the photo — as well as detailed information on the film development and the printing of the negative. On the opposite end of the spectrum is the well known photographer Minor White. When asked for any technical information about his photos, he would simply reply, "For technical data — the camera was used faithfully."

My position on technical matters is closer to Minor White's. I also find kinship with the contemporary photographer Ralph Gibson, whose method of operation is, "One camera, one lens, and one film." I have found I operate and create best when I am working with just the bare necessities. From the equipment I use to the actual composing of an image, I try to simplify. When I am in the field framing an image and taking a visual inventory of my composition, I seek to eliminate from the frame any element that I feel does not contribute to what I am trying to communicate in the final photo. I conveyed this method to my students by telling them that I have seen infinitely more images ruined because they contain too much than photos that are ruined because they are too minimal.

The goal of simplifying my working method can readily be seen with my equipment. I basically use one camera, which is a large format 4x5 view camera. It is a wooden field camera (as opposed to a studio camera) and is of minimal weight for a view camera. I do have a medium format camera that is somewhat lighter and more compact that I use as a backup. The view camera has been around since the 1850s, and except for some refinements, it is basically unchanged. It was a view camera that Mathew Brady used to document the Civil War. It is the same camera that Timothy O'Sullivan and William Henry Jackson used to capture the first photographs of the unexplored West. My own camera is about twenty-five years old and because of its simple construction and few working parts it is extremely reliable. It has been in the repair shop only once. I wonder, does anyone think today's state-of-the-art digital camera will still be in use 160 years from now? Well, how about just five years from now? With the view camera, I use the old reliable Tri-X sheet film. I have used the film for so many years that I know its characteristics and have a good deal of control with it. I use two lenses, a wide angle and a moderate telephoto. I have an assortment of filters but I tend to use a deep yellow a majority of the time and occasionally a green or a red. I have a hand-held light meter and a sturdy tripod. I employ the Zone System for exposure calculations, thereby giving me more control over the negative and the final print. That is pretty much it — simplified!

For the photograph captions in this book, I have been very careful not to give distinct locations if I feel the area is not in a protected environment. Therefore, the locations are simply captioned as "Colorado Plateau." In my decades of exploring the desert, I have seen a depressing amount of

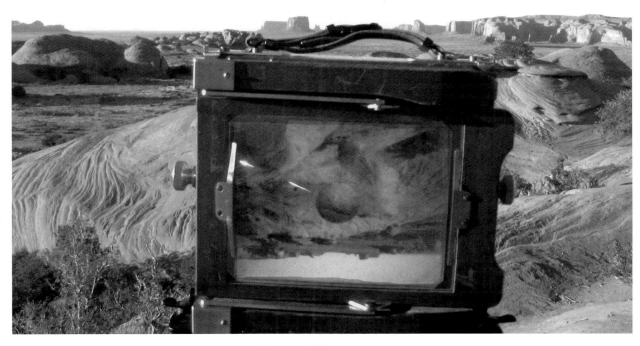

Doug's 4x5 View Camera

degradation and scarring to the very fragile landscape by all types of users. Some are well-meaning and try to avoid unnecessary disturbance to the environment. Unfortunately, there are those who are ignorant and/or insensitive to the ease with which the desert can be scarred and its beauty destroyed. I do not wish to have any part in the desert's further abuse as a result of revealing where a photo was taken.